By Jenine Zimmers
Copyright © 2022

POWER COUPLE AWARD

Jeff Schroeder and Jordan Lloyd won BIG in the Big Brother house! They met on season 11 – Jordan was crowned champion while Jeff took home America's Favorite Houseguest. They came back to compete as a couple in season 13, and got engaged on the show during season 16 when Jeff surprised Jordan with a ring after telling her they were only there to host a competition.

RIP DAN

(NOT REALLY!)

GAME SAVER AWARD

Dan Gheesling won season 10 and is referred to by some as the greatest player of all time. He never received an eviction vote that season. He returned for season 14, and, when faced with elimination, hosted his own funeral, which helped get him off the block when he was the target. He dominated the second half of the game and again reached the final two.

"I MAY HAVE A FUTURE IN SALES SELLING ICE TO ESKIMOS IF I CAN PULL THIS OFF."

BEST BB QUOTES
NO. 10

– Dan Gheesling on the funeral stunt that saved him from eviction on Big Brother 14.

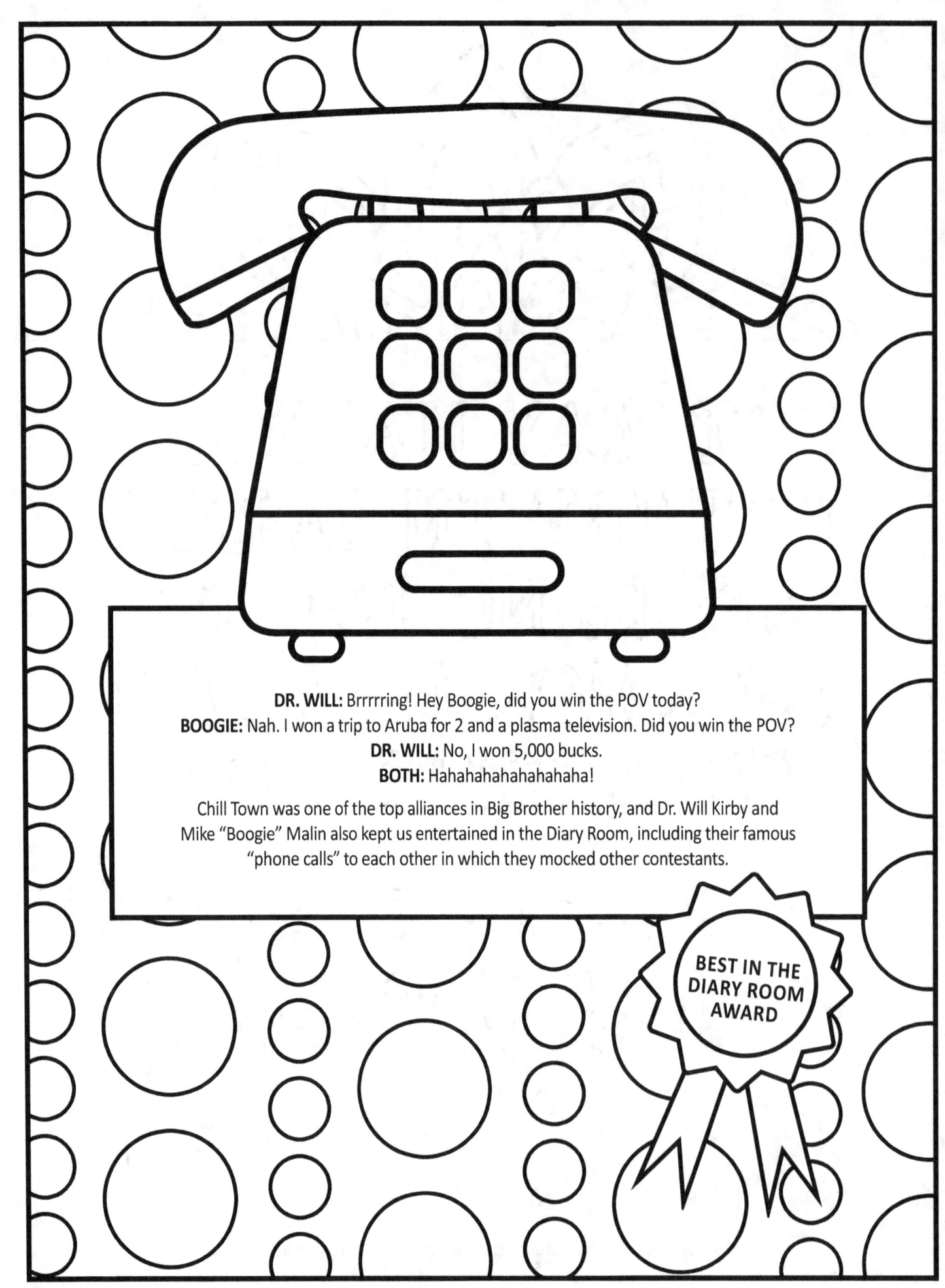

DR. WILL: Brrrrring! Hey Boogie, did you win the POV today?
BOOGIE: Nah. I won a trip to Aruba for 2 and a plasma television. Did you win the POV?
DR. WILL: No, I won 5,000 bucks.
BOTH: Hahahahahahahahaha!

Chill Town was one of the top alliances in Big Brother history, and Dr. Will Kirby and Mike "Boogie" Malin also kept us entertained in the Diary Room, including their famous "phone calls" to each other in which they mocked other contestants.

BEST IN THE DIARY ROOM AWARD

"THIS IS THE BIG BROTHER HOUSE, YOU CAN BOUNCE CHECKS."

— Mike "Boogie" Malin while serving as coach for new players during Big Brother 14.

> "'Who wants to see my HOH room?' Nobody! In fact, we'd rather hang ourselves."

— Britney Haynes exhibiting her trademark sarcasm on Big Brother 12.

Chima Simone is best remembered for her rebellious behavior on Big Brother! In Season 11, she refused to enter the Diary Room and wear her microphone on several occasions. The final straw came when she threw her microphone into the pool. Big Brother producers coaxed her into the Diary Room and lead her right out of the Big Brother house. But at least she made a splash!

MOST DRAMATIC AWARD

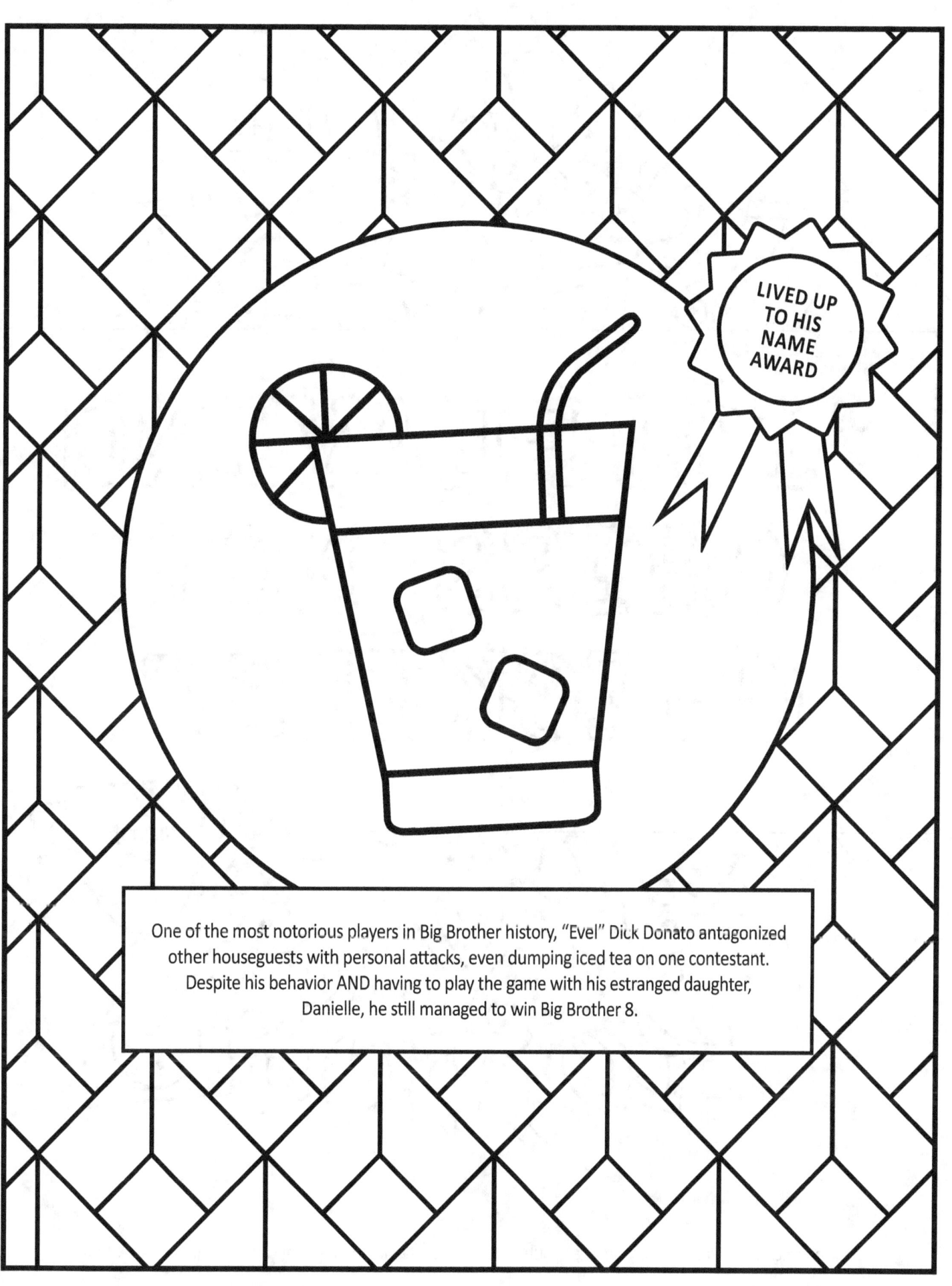

LIVED UP TO HIS NAME AWARD

One of the most notorious players in Big Brother history, "Evel" Dick Donato antagonized other houseguests with personal attacks, even dumping iced tea on one contestant. Despite his behavior AND having to play the game with his estranged daughter, Danielle, he still managed to win Big Brother 8.

"I'M PLAYING CHESS, NOT CHECKERS."

BEST BB QUOTES

NO. 7

– Jackson Michie said this so many times en route to his season 21 victory that it became a running joke with fans.

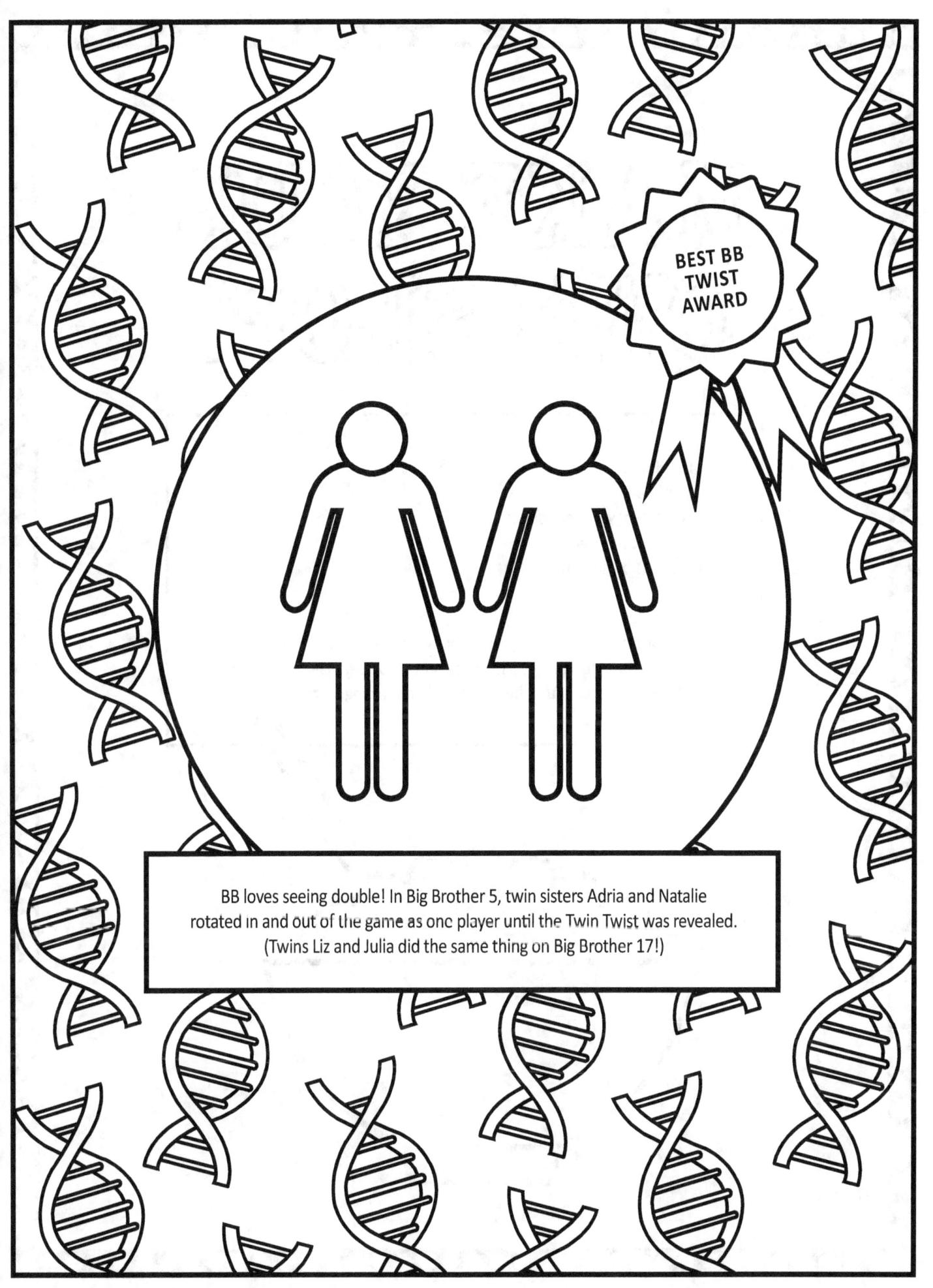

MAKE YOUR OWN SLOP!

INGREDIENTS:
3 cups of oats
3/4 cup of whey protein isolate
1/2 cup of soy protein
3 teaspoons of vitamin powder

DIRECTIONS:
Boil 3 quarts of water in a large pot. Stir in oats, and reduce heat to medium. Simmer for about 25 minutes, stirring occasionally, until oats absorb liquid. Remove from heat and stir in remaining ingredients.

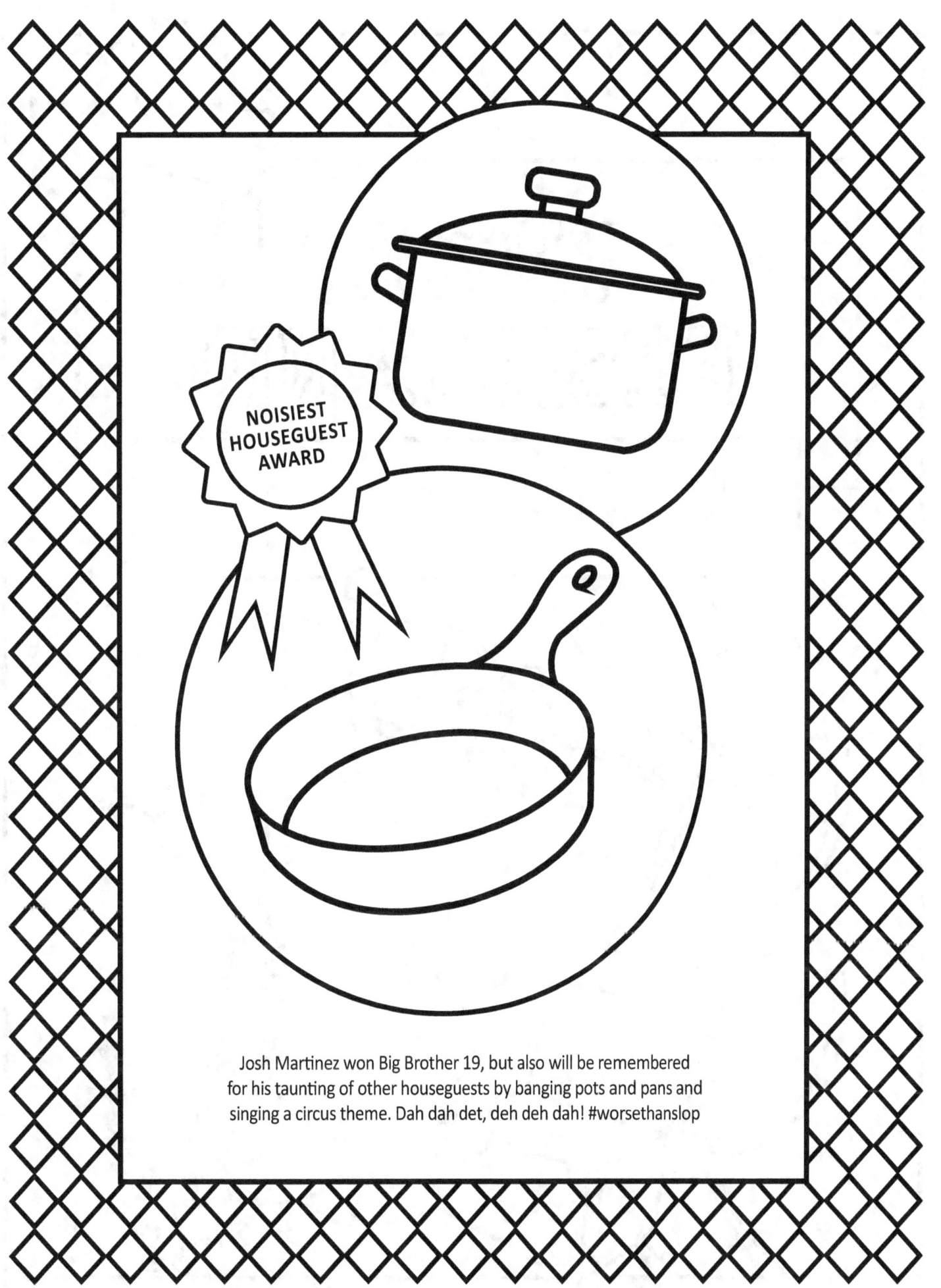

THE BB FISH TANK!

On Big Brother, the camera switches to a view of the house fish tank when something is happening that production doesn't want you to see or hear.

BIG BROTHER WORD SEARCH

A	H	X	G	L	T	Y	R	I	U	V	J	K	Q	P	G	X	S	Q
D	J	C	L	K	Y	X	E	N	J	C	D	L	U	S	E	Y	I	R
G	R	U	T	X	I	Z	S	L	T	X	F	J	H	L	T	A	D	S
K	P	X	R	G	E	A	D	H	G	R	F	F	J	O	Y	D	P	C
K	T	E	W	Y	U	T	T	A	F	T	G	F	K	P	P	G	Q	J
L	B	D	R	Y	A	O	G	S	S	Y	V	G	P	T	E	K	V	H
A	L	S	N	S	A	P	B	D	F	H	O	F	T	E	Q	K	C	E
M	O	S	G	D	Q	D	H	W	G	J	I	D	A	N	V	R	X	D
P	C	U	H	B	A	C	K	D	O	O	R	E	Q	G	S	I	C	S
T	K	P	A	F	L	K	C	G	B	F	K	S	C	H	Q	M	C	H
G	R	A	S	T	I	M	S	A	H	F	L	R	B	A	O	R	Y	T
X	U	S	D	A	P	N	V	W	J	K	V	I	K	S	L	T	H	C
Q	O	F	B	R	L	R	O	I	U	J	E	O	R	D	I	H	G	A
K	S	R	D	T	L	E	T	O	A	H	J	H	T	W	P	O	P	X
F	P	O	L	H	K	S	E	G	S	G	N	Y	O	E	L	H	O	P
D	O	P	F	J	H	F	J	T	D	F	M	W	S	G	L	F	L	D
S	V	L	W	U	G	T	F	T	F	D	O	S	E	F	I	T	E	O
A	H	E	I	O	R	G	U	N	E	X	P	E	C	T	E	D	J	P
B	X	W	O	P	X	B	C	M	V	Y	Y	D	P	I	G	S	H	L

Words can horizontal, vertical or diagonal!

WORDS TO FIND:

Backdoor	Slop	Vote
POV	Evict	Block
HOH	Unexpected	Jury

BEST BB QUOTES

NO. 6

"SLOP, TO ME, IS LIKE AN EX-GIRLFRIEND. I WANT NOTHING TO DO WITH IT."

– Enzo "The Meow-Meow" Palumbo, who appeared on seasons 12 and 22.

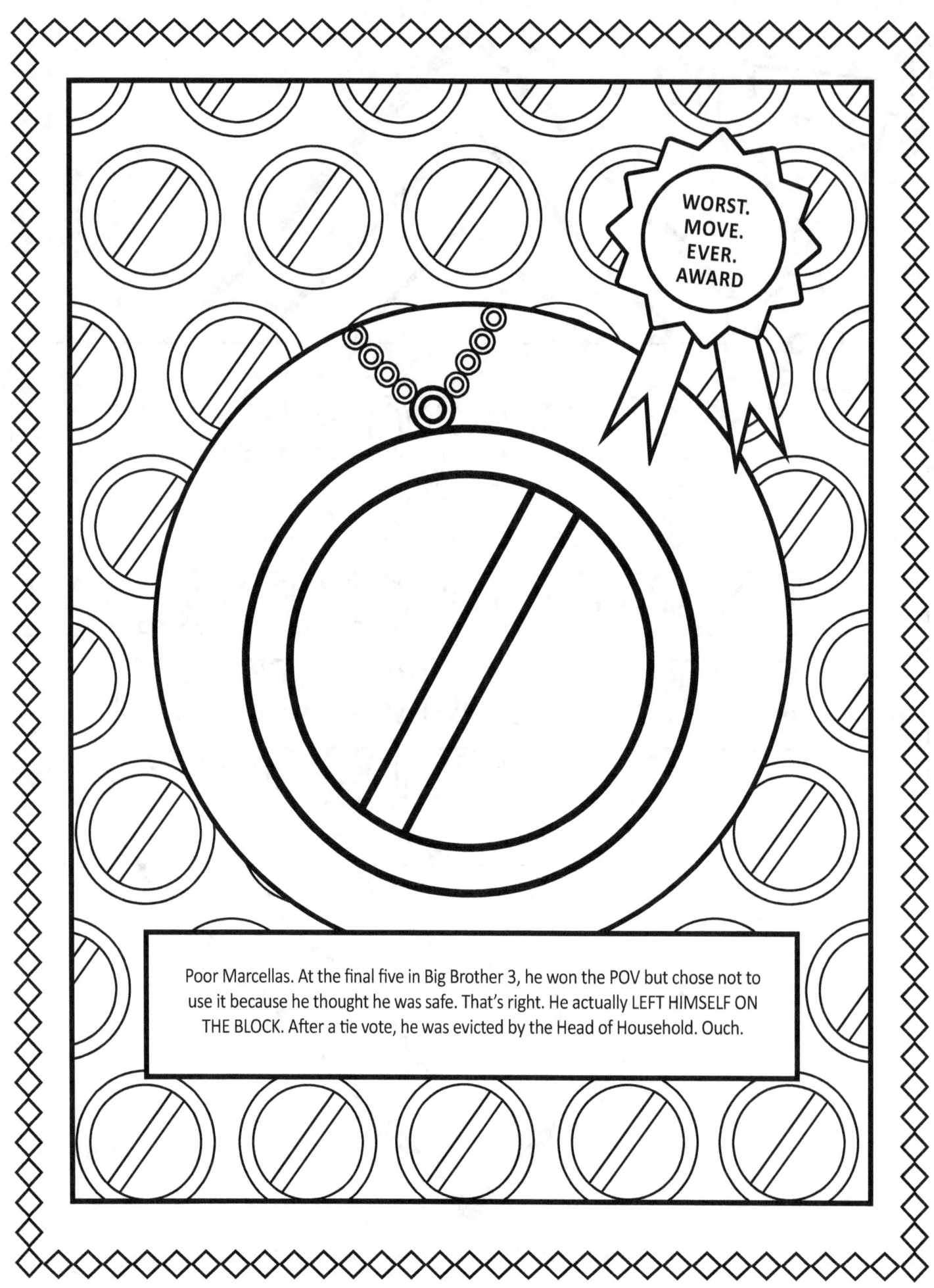

BIG BROTHER TRIVIA

1. Name the first person evicted in season 1.

2. Who was the only houseguest to be evicted three times in one season?

3. Which houseguest was nicknamed Beast Mode Cowboy?

4. Who wore the first unitard as punishment in Big Brother history?

5. Who is the first person to be crowned champion by unanimous vote?

6. What book inspired the name Big Brother?

7. In what year did Big Brother premiere in the United States?

8. Who won the first season of Celebrity Big Brother?

9. On what season did slop make its first appearance?

10. How did recurring character Otev get his name?

(Answers appear on final page.)

ALLIANCE NAME GAME

Match the Big Brother alliance with its members! (Answers on final page.)

1. Bomb Squad
2. Scamper Squad (a.k.a. Freaks and Geeks)
3. The Veterans
4. The Detonators
5. Legion of Doom
6. The Four Horsemen
7. The Quack Pack
8. The Friendship
9. Girl Power
10. The Exterminators
11. Sovereign Six
12. Level Six
13. The Renegades
14. The Brigade
15. The Hitmen

A. Season 14: Britney, Dan, Danielle, Ian, Shane
B. Season 6: Howie, James, Janelle, Kaysar, Rachel, Sarah
C. Season 4: Alison, Erika, Jun
D. Season 20: Angela, Brett, Kaycee, Rachel, Tyler, Winston
E. Season 17: Austin, Julia, Liz, Steve, Vanessa
F. Season 16: Christine, Cody, Derrick, Frankie, Zach
G. Season 7: Danielle, Dr. Will, James, Mike Boogie
H. Season 6: April, Beau, Eric, Ivette, Jennifer, Maggie
I. Season 15: Andy, GinaMarie, Judd, Spencer
J. Season 13: Brendon, Daniele, Dick, Jeff, Jordan, Rachel
K. Season 16: Cody and Derrick
L. Season 10: Dan and Memphis
M. Season 16: Amber, Caleb, Christine, Derrick, Devin, Frankie, Hayden, Zach
N. Season 5: Cowboy, Drew, Jase, Scott
O. Season 12: Enzo, Hayden, Lane, Matt

"HE'S NOT THE WOLF IN SHEEP'S CLOTHING, I AM."

BEST BB QUOTES

NO. 5

— Season 14 winner Ian Terry, who made moves in secret so that other players would take the blame.

"STOP PLAYING BIG BABY, LET'S PLAY BIG BROTHER."

— Nicole Franzel during her speech before eviction in her first appearance on Big Brother.

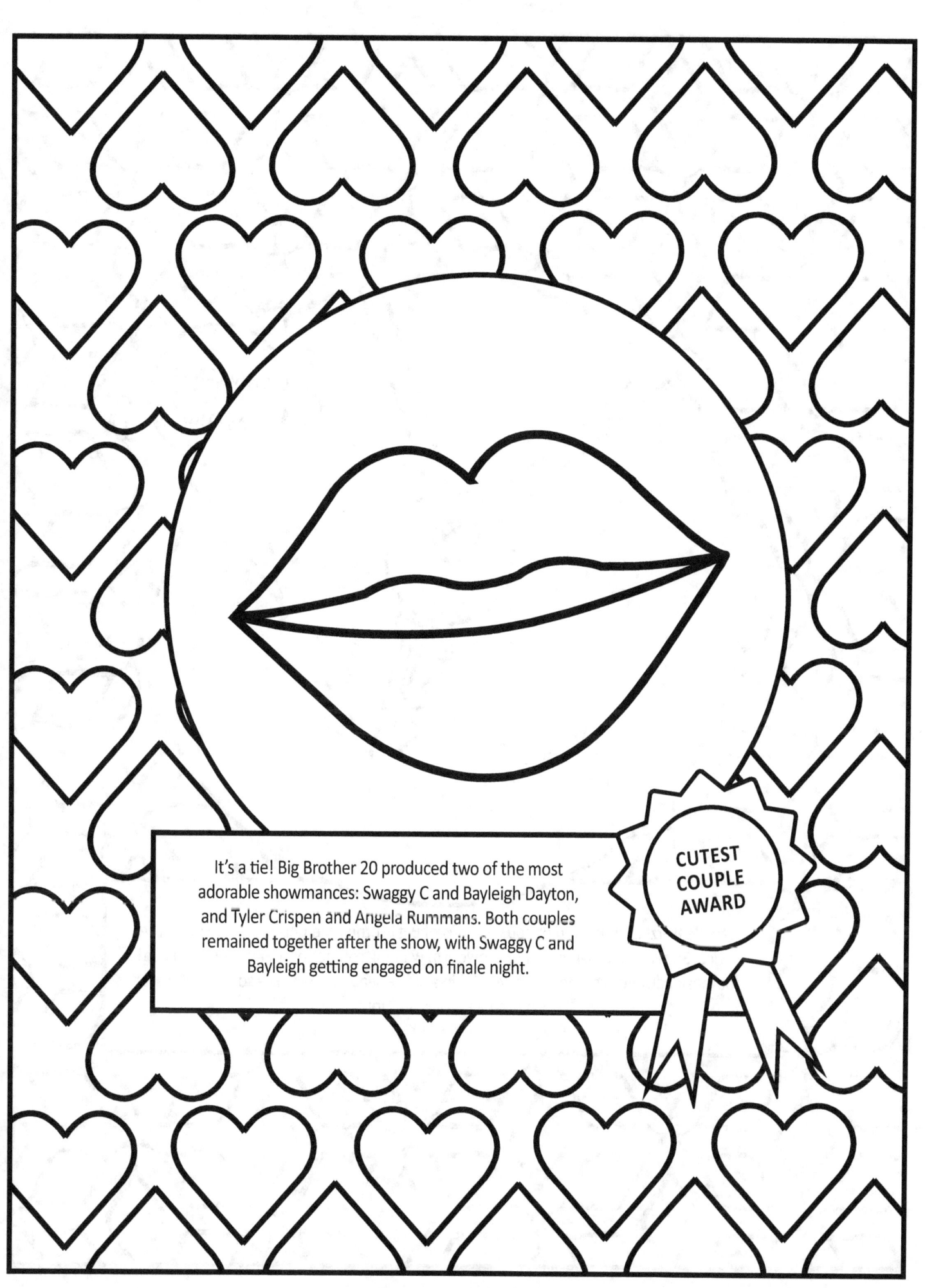

It's a tie! Big Brother 20 produced two of the most adorable showmances: Swaggy C and Bayleigh Dayton, and Tyler Crispen and Angela Rummans. Both couples remained together after the show, with Swaggy C and Bayleigh getting engaged on finale night.

CUTEST COUPLE AWARD

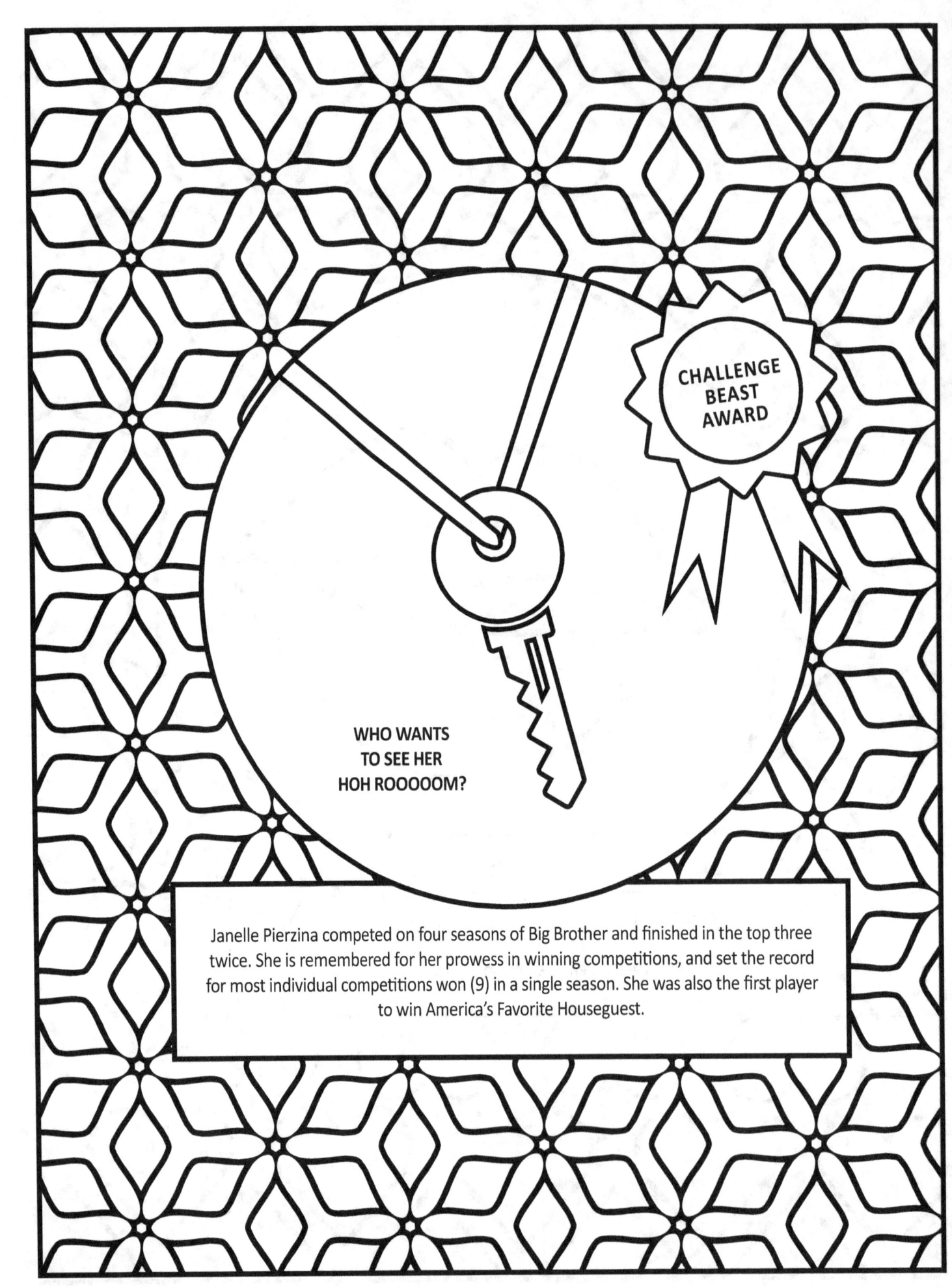

CHALLENGE BEAST AWARD

WHO WANTS TO SEE HER HOH ROOOOOM?

Janelle Pierzina competed on four seasons of Big Brother and finished in the top three twice. She is remembered for her prowess in winning competitions, and set the record for most individual competitions won (9) in a single season. She was also the first player to win America's Favorite Houseguest.

BYE, BYE, B*TCHES!

– Janelle Pierzina said her well-known line on Big Brother 6, after nominating two of her house enemies.

The Cookout on Big Brother 23 was by far the most dominant alliance in BB history. Players Azah Awasum, Derek Frazier, Kyland Young, Hannah Chaddha, Tiffany Mitchell, and Xavier Prather formed the alliance during week one, and made it all the way to the final six. Their goal was to crown the first ever black winner of the show, and they did it when Xavier won the title on finale night.

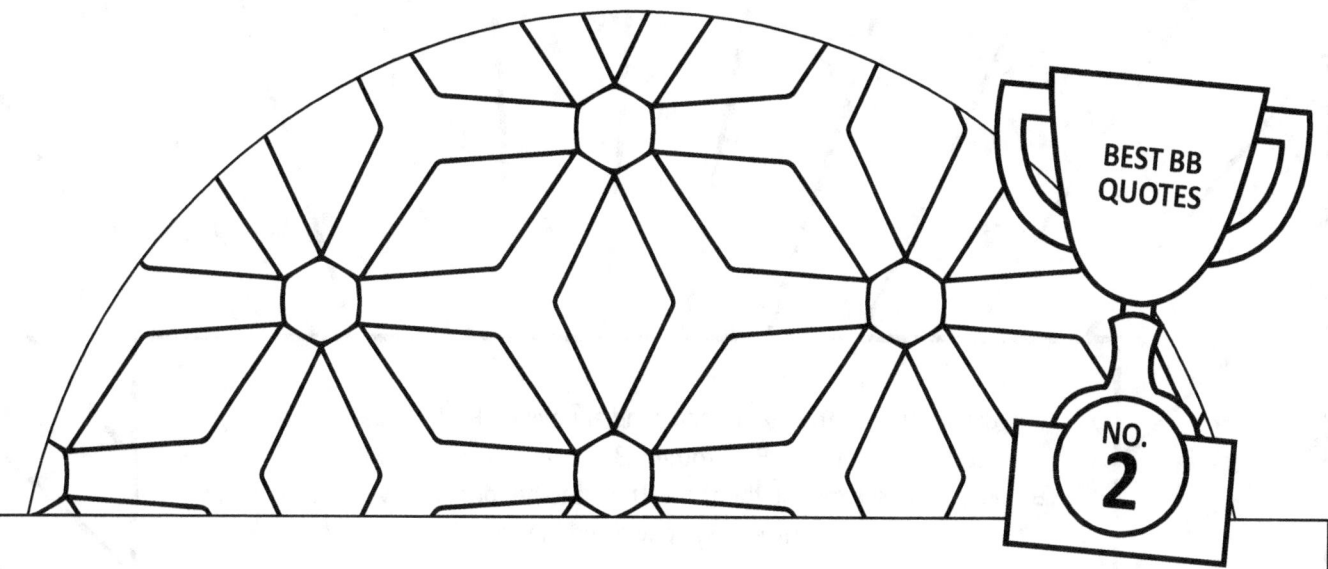

"YOU CAN JUST CALL ME THE GRILL MASTER."

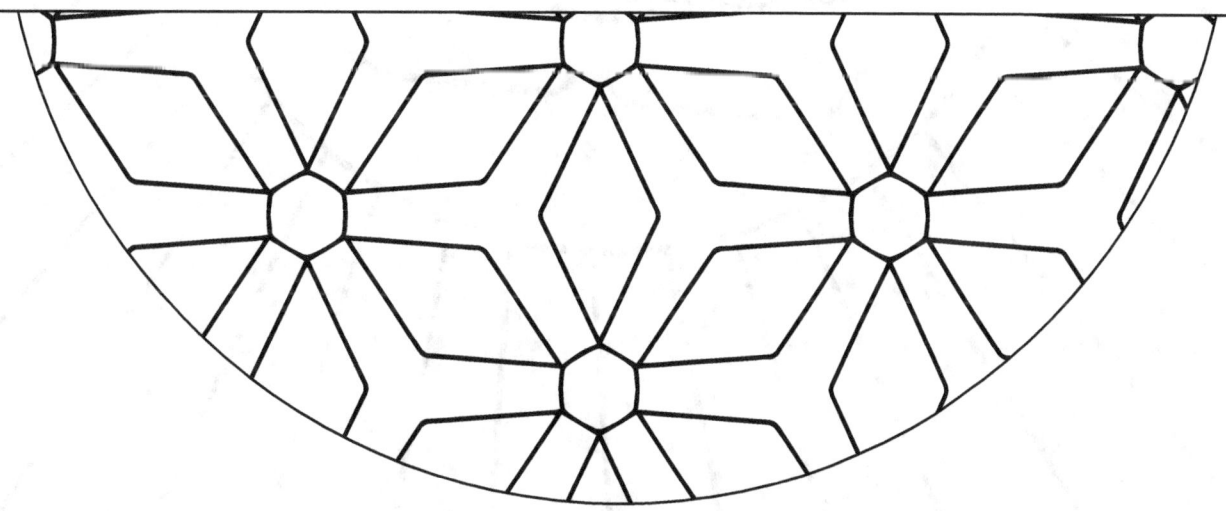

– Tiffany Mitchell after joining the Cookout alliance but planning to be the last one standing.

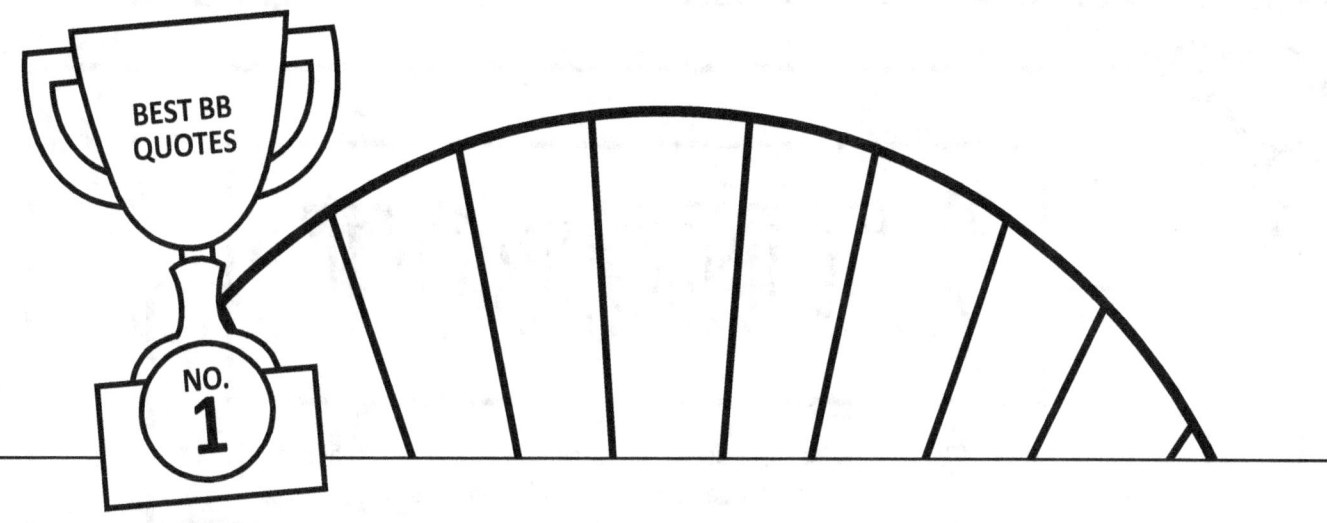

"FLOATERS, YOU BETTER GRAB A LIFE VEST."

– Rachel Reilly after winning Head of Household in season 6. This line is one of the most quoted in BB history!

ZINGBOT

CLAIM TO FAME: Zinging houseguests with insults! Zingbot first appeared on Big Brother 12 and has been ruthless ever since.

Lane, they say everything is big in Texas... except your brain. Zing!

Jeff, 1995 called. They want their soul patch back. Zing!

Britney, I have a half million dollars to donate. Please tell me more about the charity you gave yours to. I think it was called the Brigade. Zing!

McCrae, I finally understand why you're always wearing shorts: Because Amanda wears the pants. Zing!

Ian, for a chemical engineering student, it's amazing how little chemistry you have with the ladies. Zing!

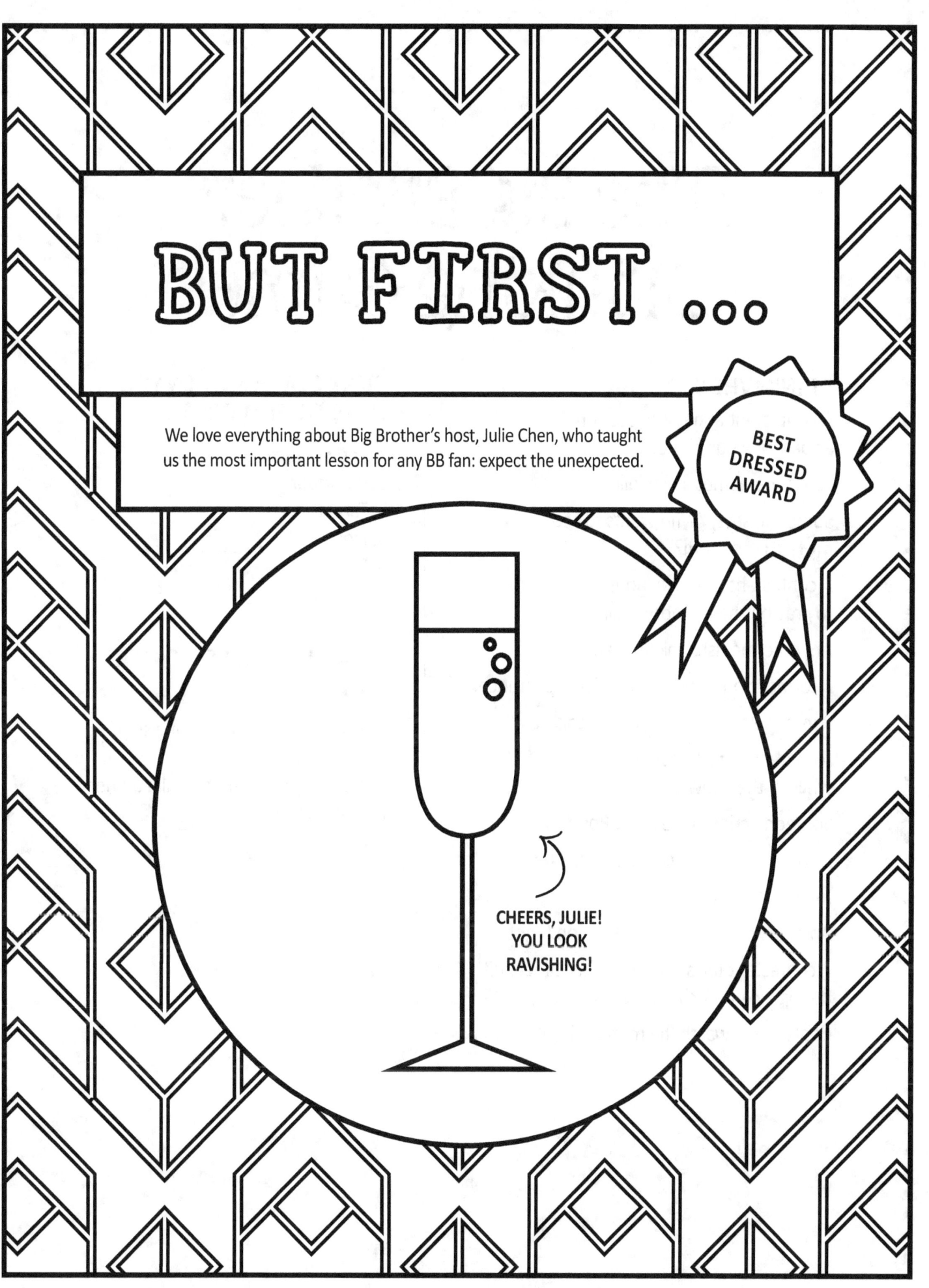

The Big Brother Drinking Game

DRINK WHEN...

A contestant appears in costume as part of a punishment.

Someone names a new alliance.

Someone says, "Who wants to see my HOH rooooom?"

A contestant's picture fades to gray on the Memory Wall.

Anytime the fish tank appears.

A former houseguest makes an appearance.

Someone says, "I HAVE to win this POV."

A contestant has a conversation while in the shower.

Someone cries in the Diary Room.

Anyone says, "Expect the unexpected."

Julie says, "But first ..."

Anyone mentions Double Eviction Night.

A contestant talks over his or her time limit during a ceremony speech.

Contestants watch the monitor in HOH room.

CLINK GLASSES WHEN YOU HEAR THESE WORDS ...

1. Showmance
2. Backdoor
3. Target
4. Floater
5. Safe

STAND UP AND YELL CHEERS WHENEVER ...

1. Someone is shown eating slop.
2. Otev appears.
3. A player compliments Julie on her appearance.

Thank you!

The purchase of this book supported
a small business owner.

TRIVIA ANSWERS

1. William Collins was the first person evicted in season 1.
2. Victor Arroyo in Big Brother 18.
3. Caleb Reynolds was Beast Mode Cowboy.
4. Jen Johnson wore the first unitard on season 8.
5. Dan Gheesling won season 10 with all the votes.
6. George Orwell's novel "Nineteen Eighty-Four," with its theme of constant surveillance.
7. Big Brother premiered in the United States in 2000.
8. Marissa Jaret Winokur
9. Season 7. Before then, contestants ate peanut butter and jelly sandwiches only when Have Nots.
10. Otev is Veto spelled backward!

MATCHING ALLIANCE NAME GAME ANSWERS

1. M
2. E
3. J
4. F
5. G
6. N
7. A
8. H
9. C
10. I
11. B
12. D
13. L
14. O
15. K

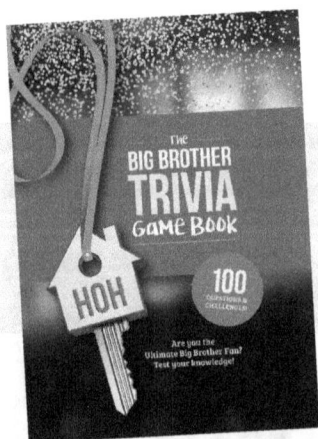

Check out "The Big Brother Trivia Game Book," now available on Amazon!

www.ingramcontent.com/pod-product-compliance
Lightning Source LLC
Chambersburg PA
CBHW081707220526

45466CB00009B/2902